INSTANT WALL ART:
enchanted mushrooms

45 Ready-to-Frame Illustrations
for Your Home Décor

SARA RICHARD

Adams Media

New York London Toronto Sydney New Delhi

Adams Media
An Imprint of Simon & Schuster, Inc.
100 Technology Center Drive
Stoughton, Massachusetts 02072

First Adams Media trade paperback edition April 2023

ADAMS MEDIA and colophon are trademarks of Simon & Schuster.

For information about special discounts for bulk purchases, please contact Simon & Schuster Special Sales at 1-866-506-1949 or business@simonandschuster.com.

The Simon & Schuster Speakers Bureau can bring authors to your live event. For more information or to book an event contact the Simon & Schuster Speakers Bureau at 1-866-248-3049 or visit our website at www.simonspeakers.com.

Interior design by Colleen Cunningham
Interior layout by Priscilla Yuen
Illustrations by Sara Richard

Manufactured in China

10 9 8 7 6 5 4 3 2 1

ISBN 978-1-5072-2026-9

INTRODUCTION

Today, enchanting mushroom prints are showing up everywhere you look—from social media to popular design websites and magazines to the walls of your friends' bedrooms and kitchens. And now, instead of having to choose between one or two expensive prints, you can choose from forty-five magical illustrations found within the pages of *Instant Wall Art: Enchanted Mushrooms* to personalize your own walls!

From the vibrant blue pinkgill to the rustic fly agaric to the delicate veiled lady, these prints feature a fascinating variety of mushroom species that capture the wonder of nature. Whether you're a fan of cottagecore or dark academia—or simply love the beauty of the forest—you're sure to find something in this book that speaks to your design aesthetic.

These images work well either placed alone in a featured spot or arranged in a group as a visually interesting gallery wall. All of the prints measure 8" × 10" and will fit in a standard mat and frame once removed from the book at the perforated edge. Some of the prints can be hand-trimmed to fit 5" × 7" or 4" × 6" frames. After removing the print from the book, use sharp scissors or a craft knife and follow the cutting lines found on the reverse side of the print to trim it to the desired size. Each cutting line indicates the corresponding frame size for easy selection and framing. So choose the prints you love, hang them on your walls, and enjoy the enchantment of nature in your own home throughout the year!

THE PRINTS

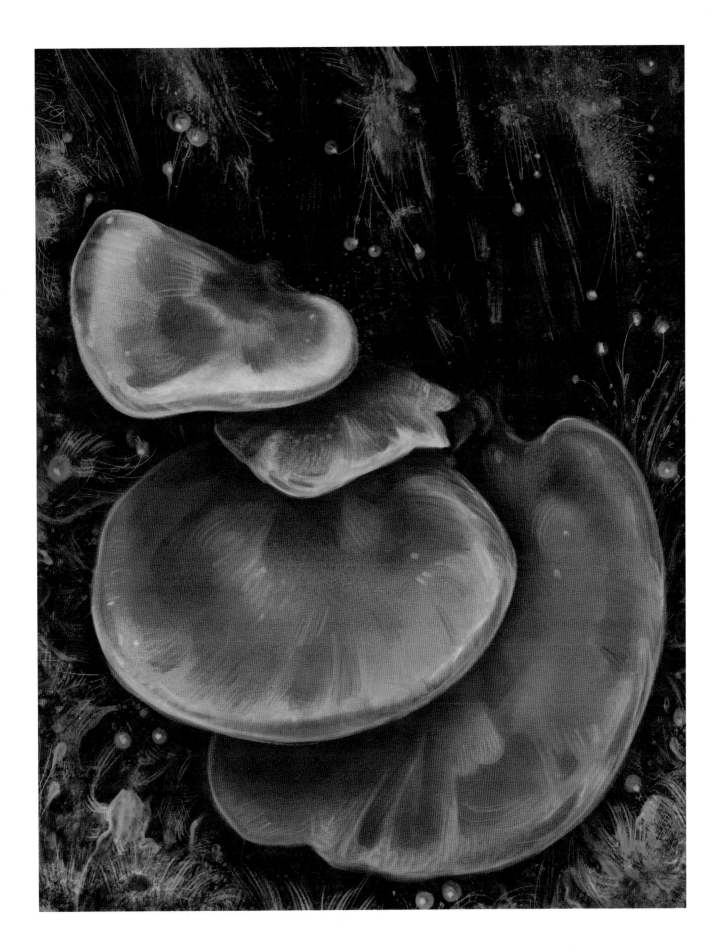

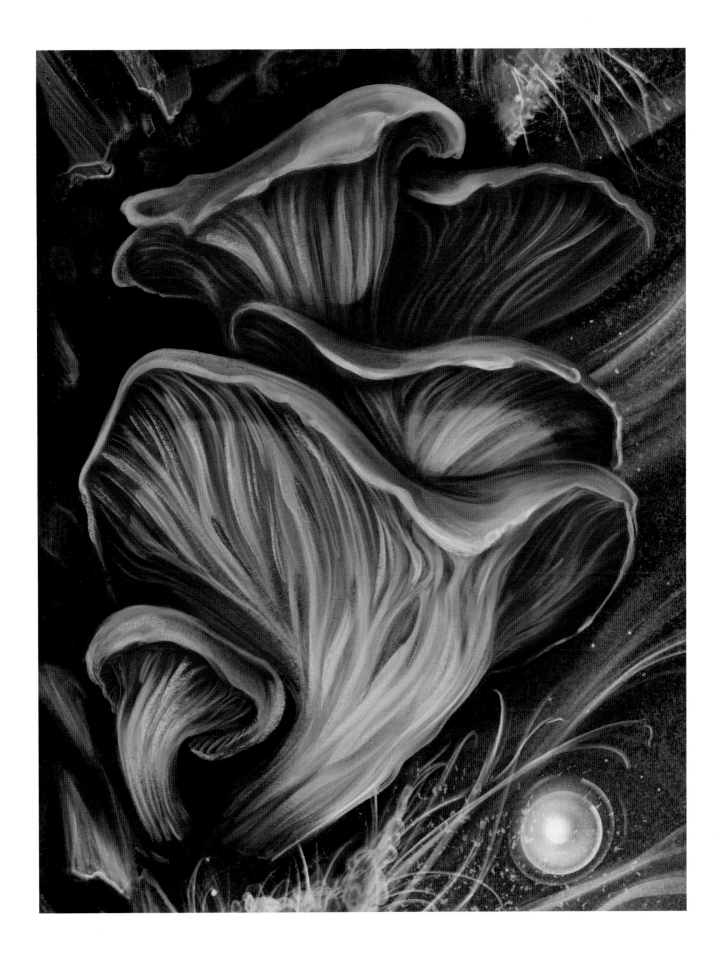

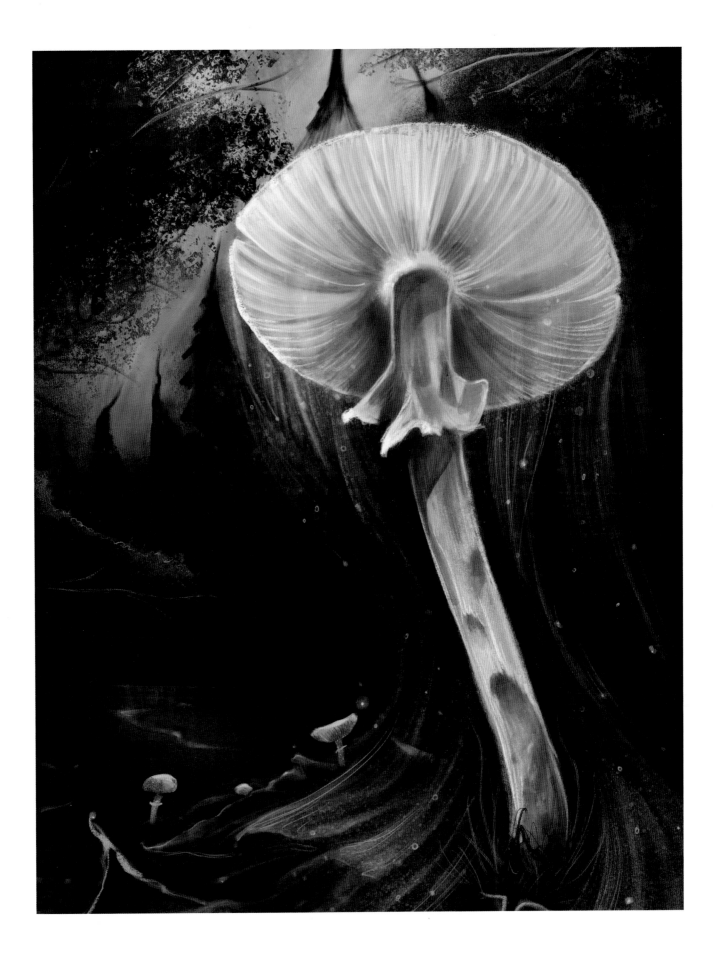

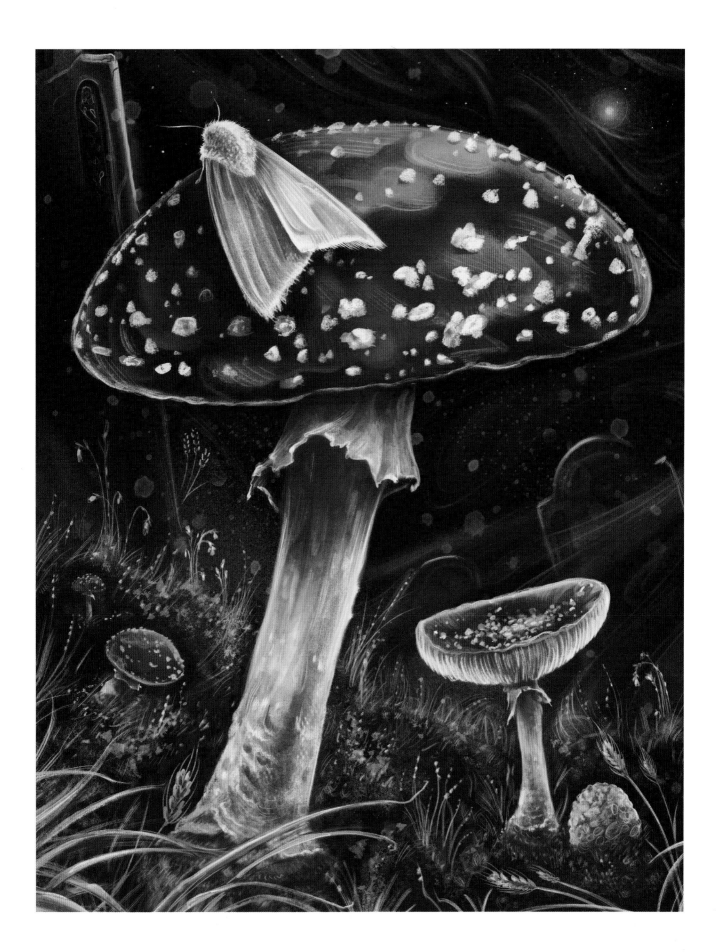

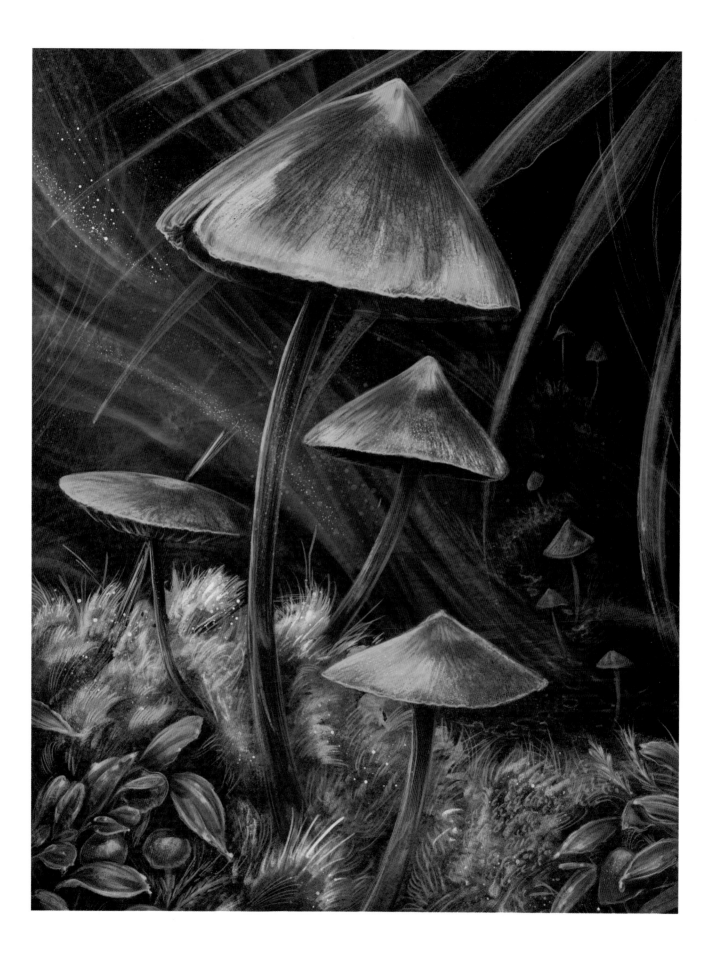

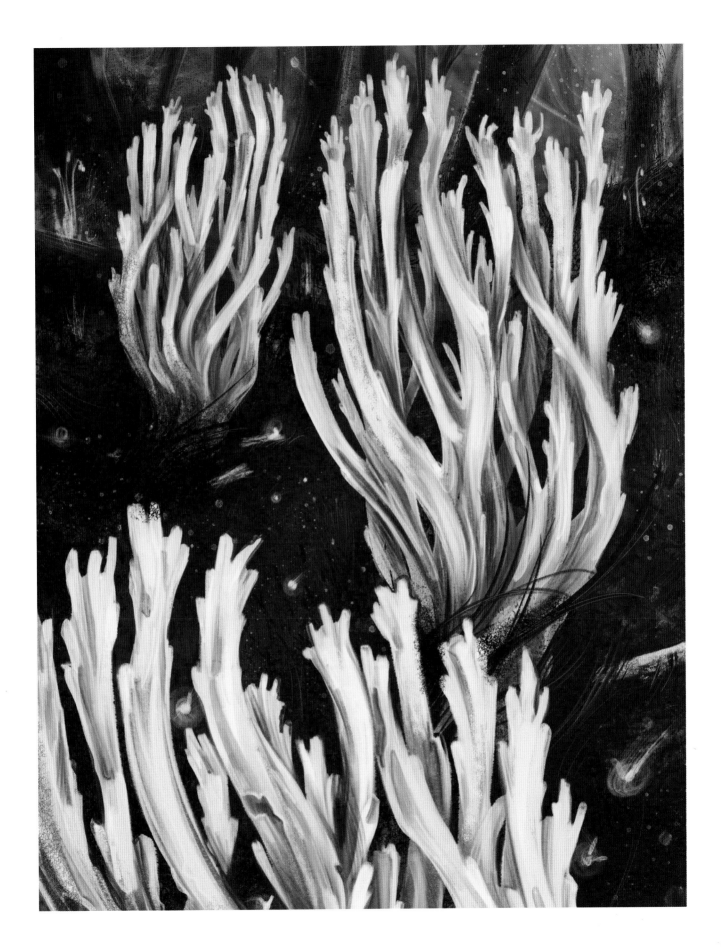

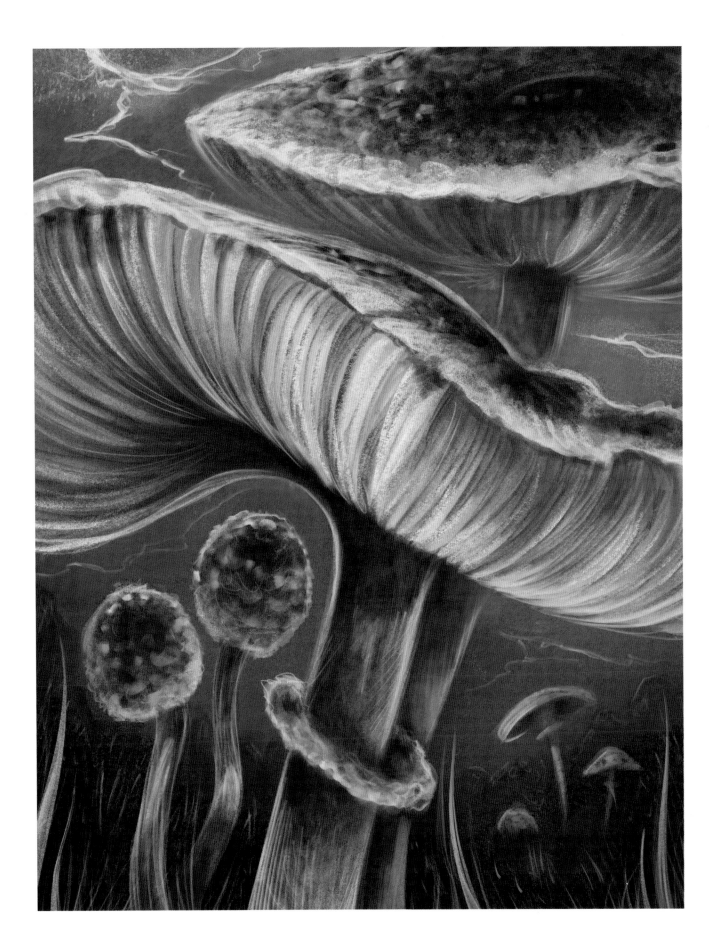

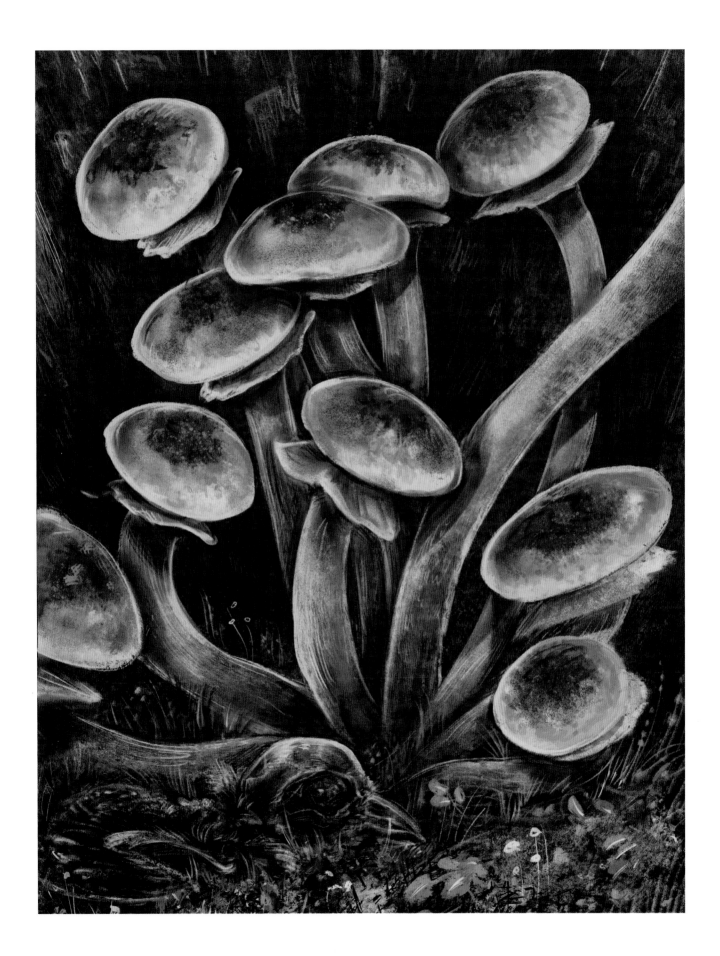

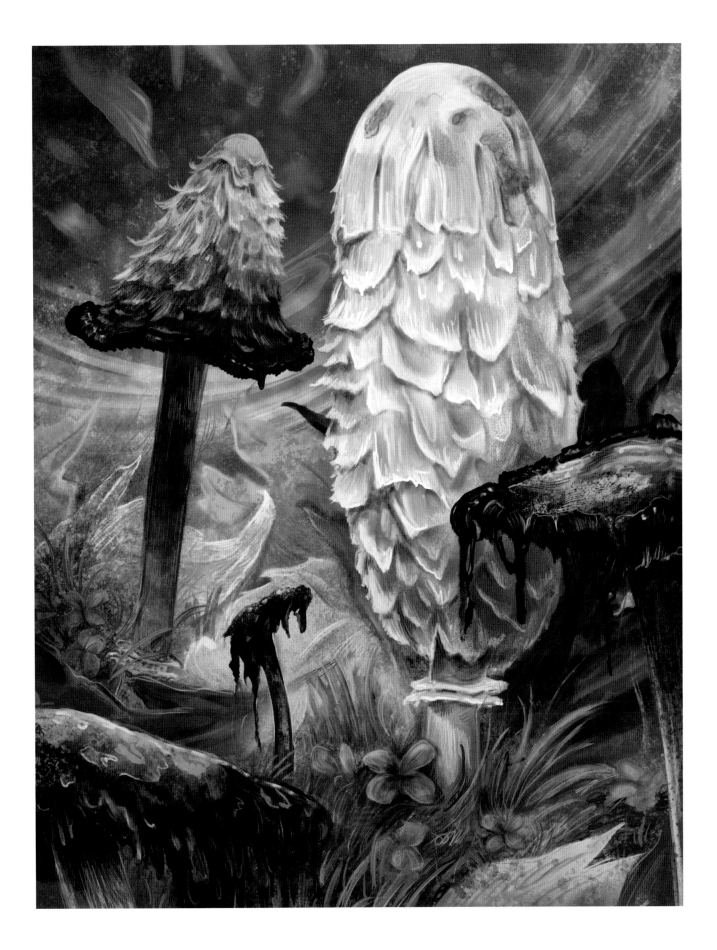

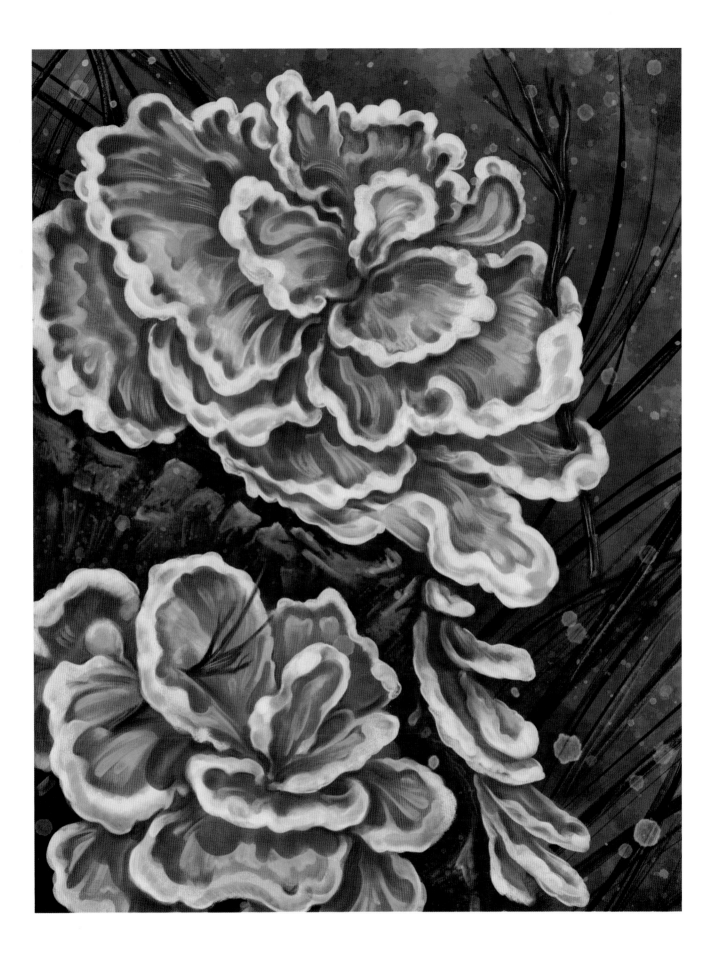

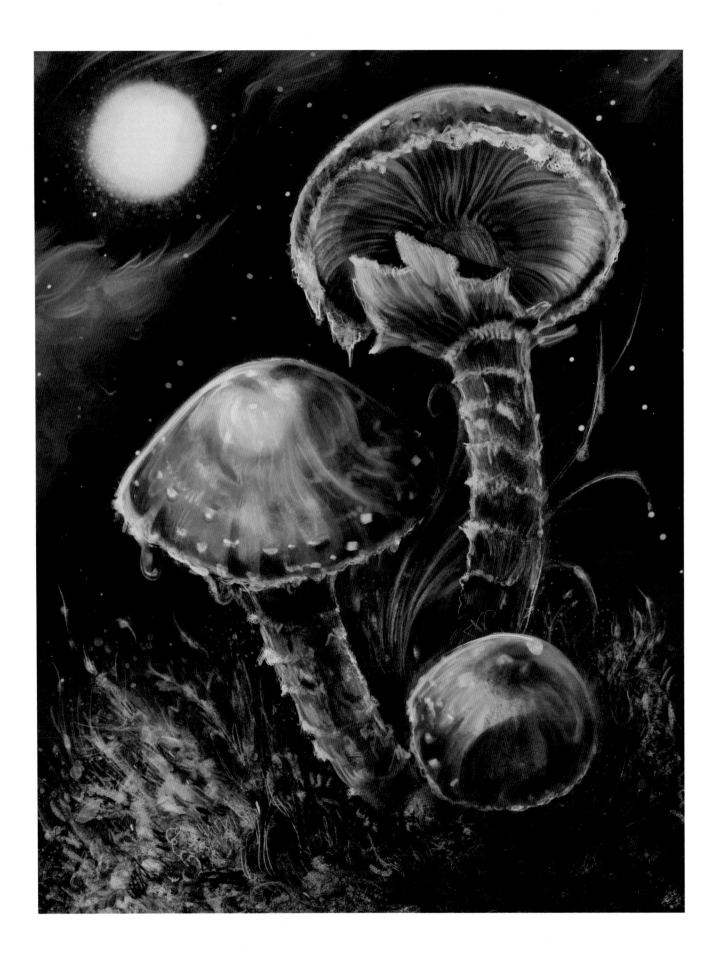

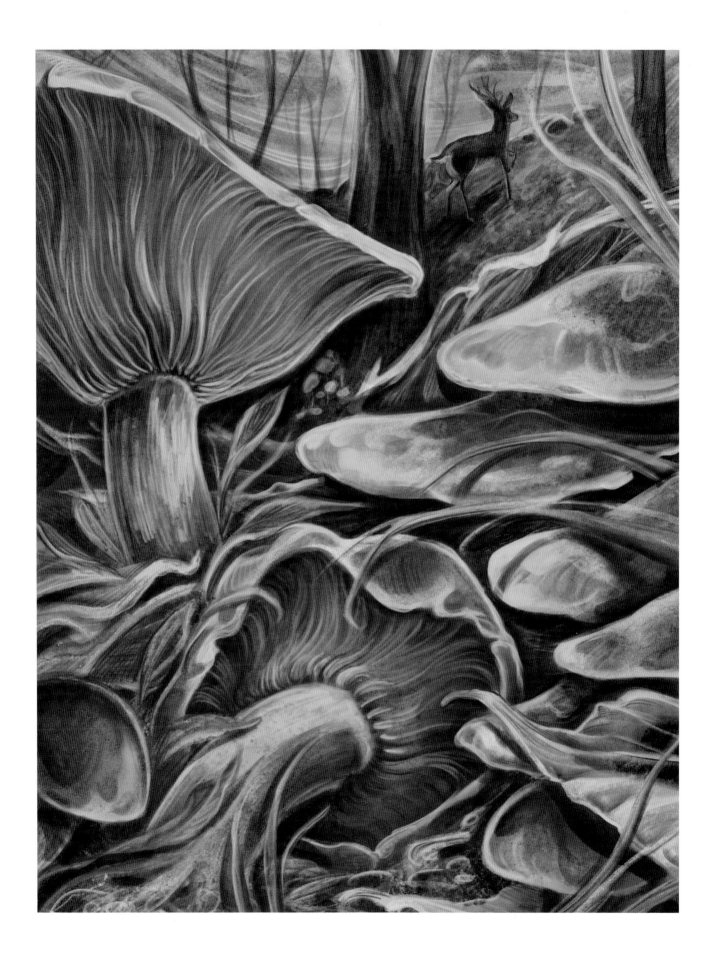

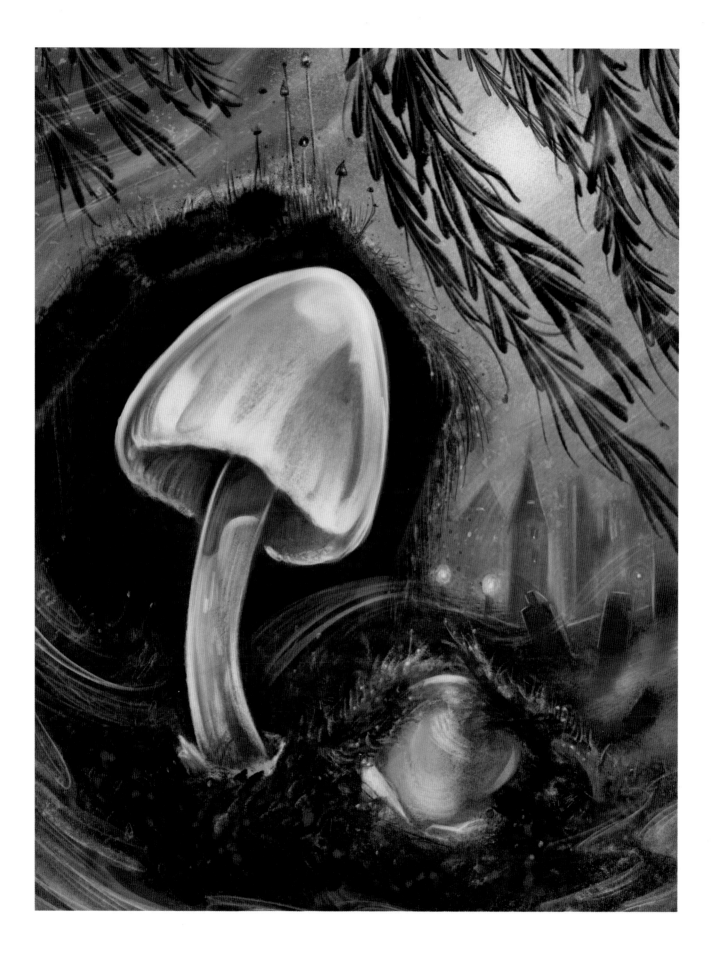

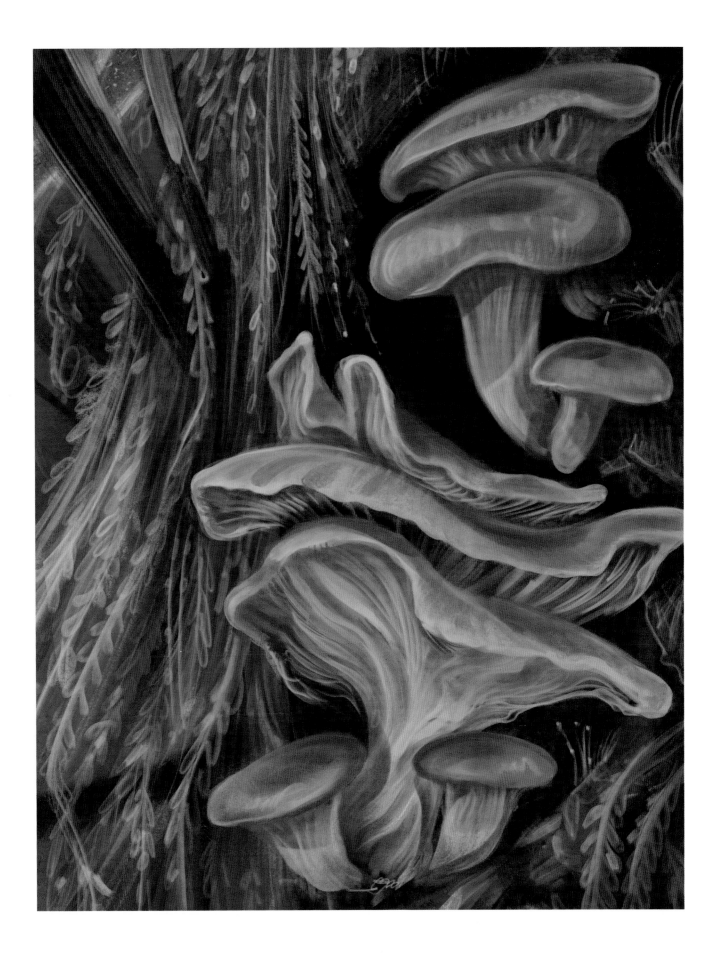

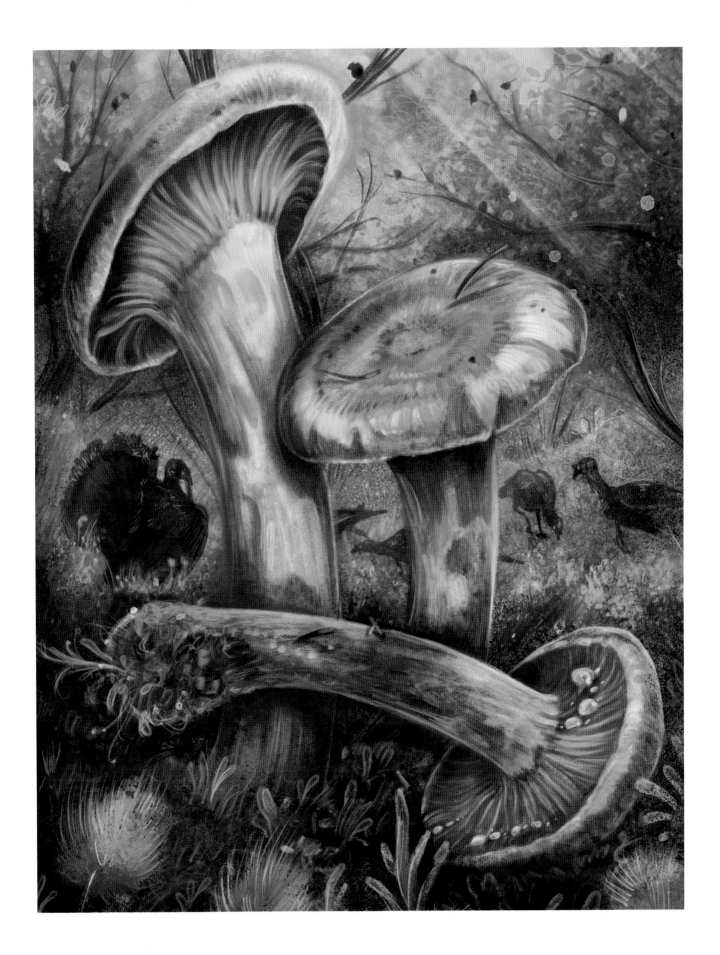

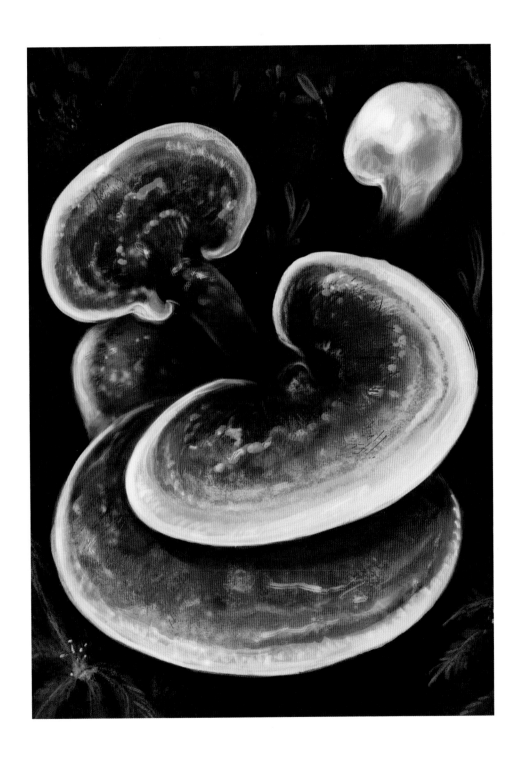

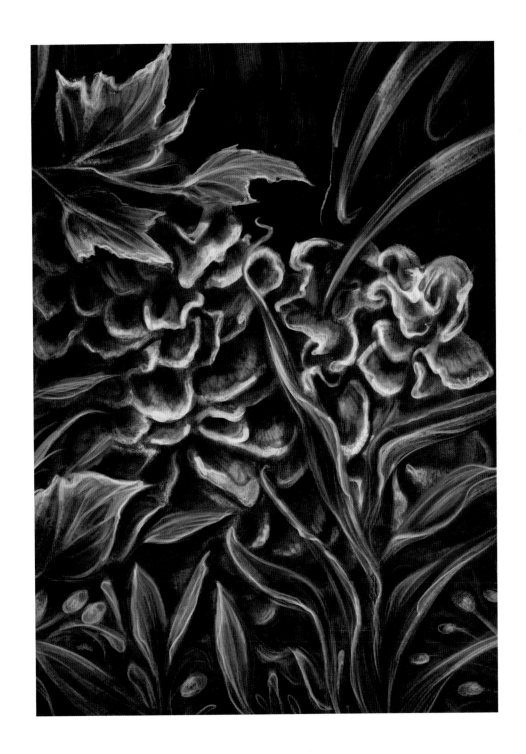

5" × 7"

8" × 10"

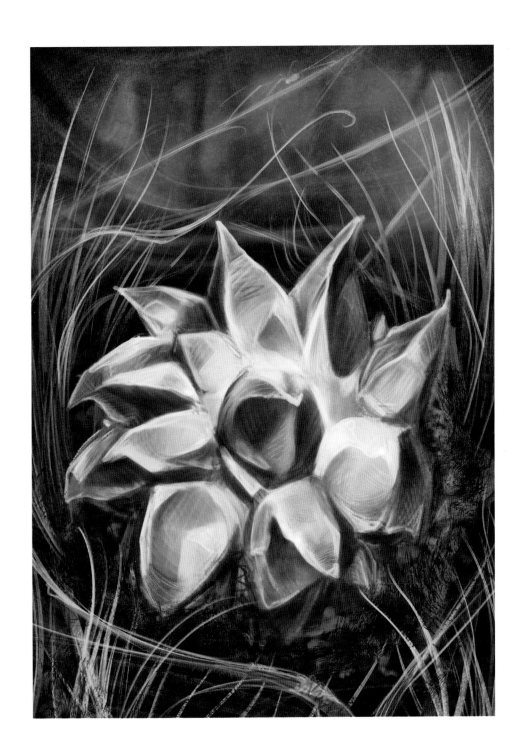

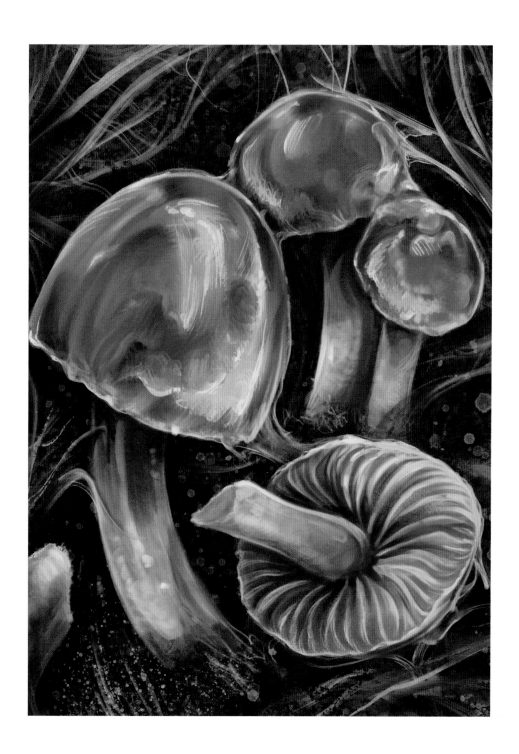

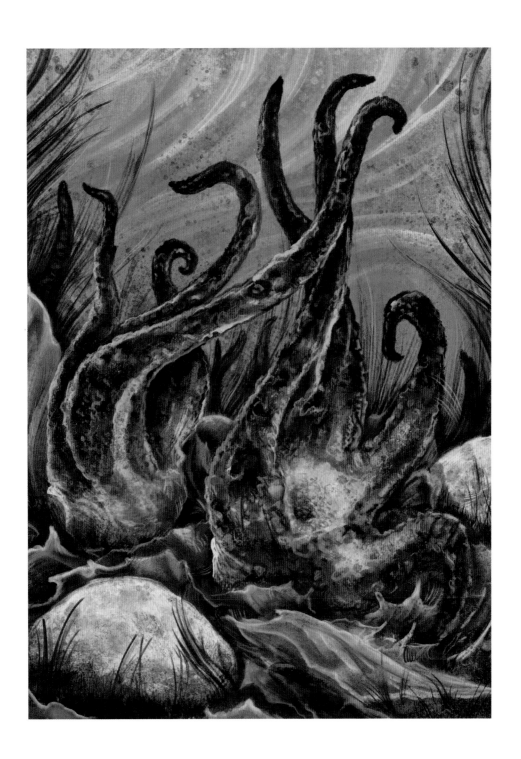

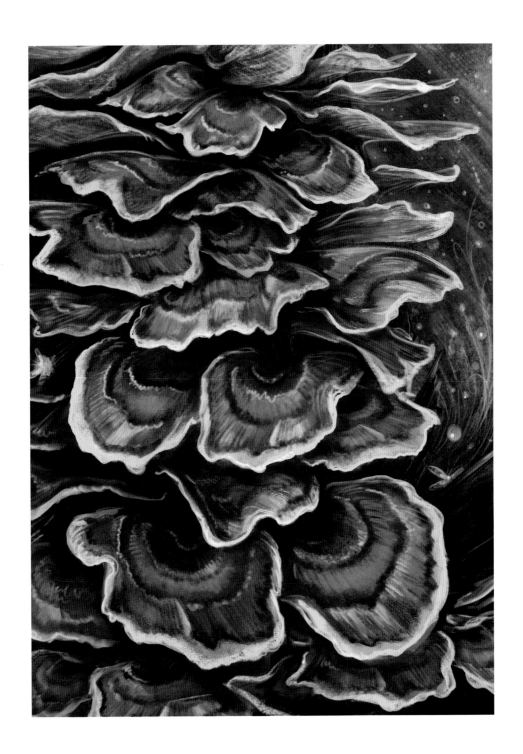

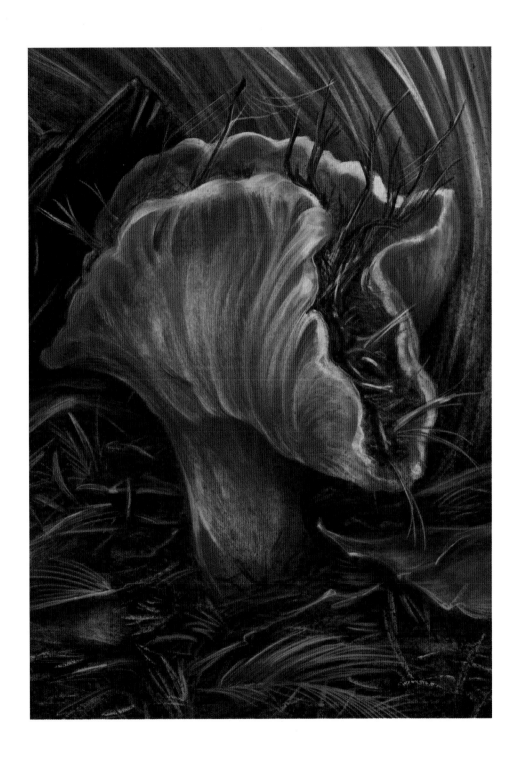

5" × 7"

8" × 10"

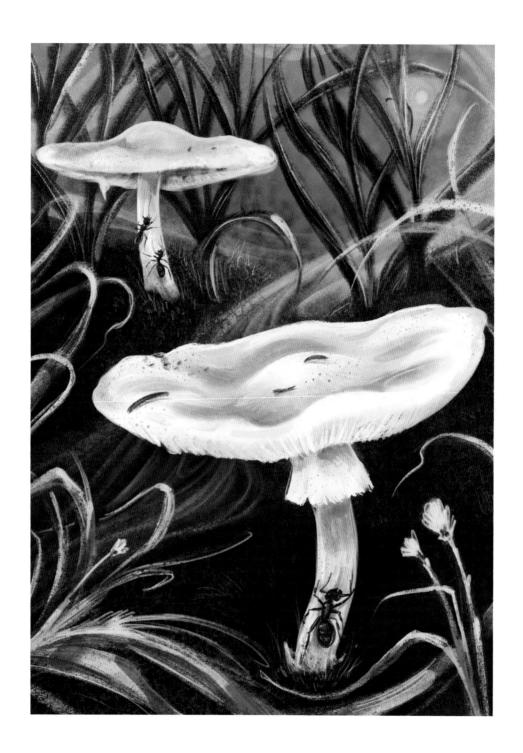

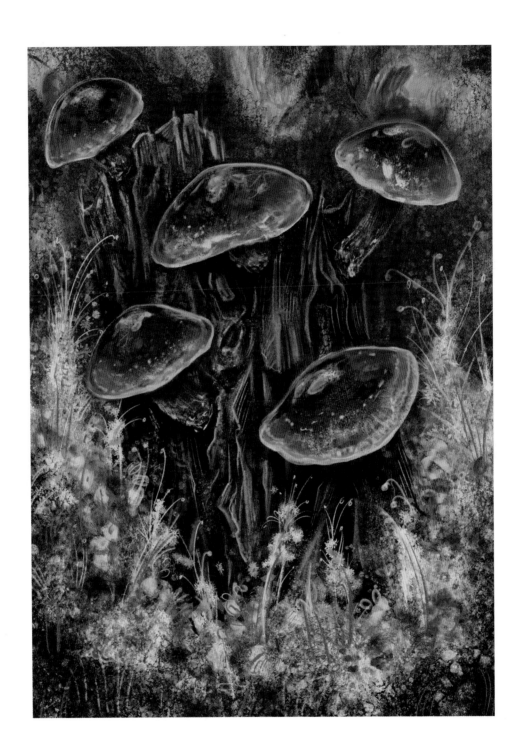

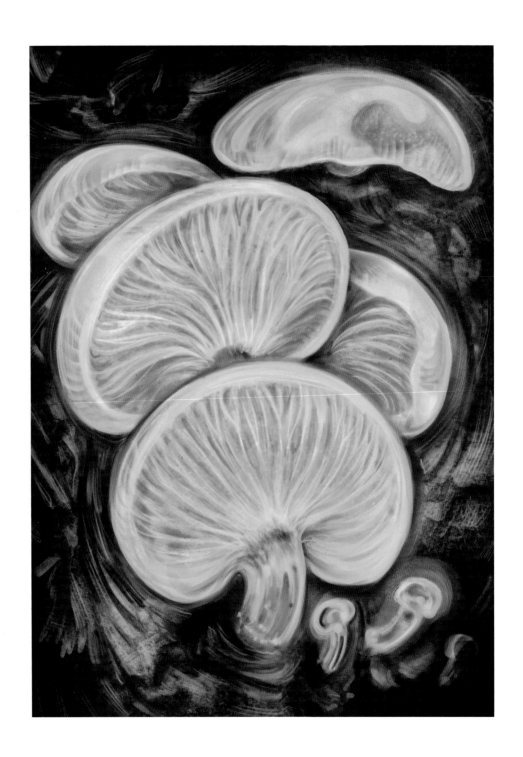

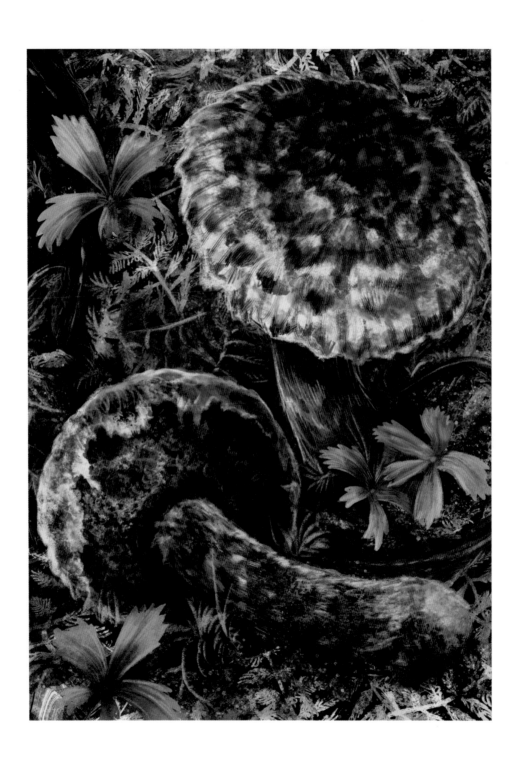

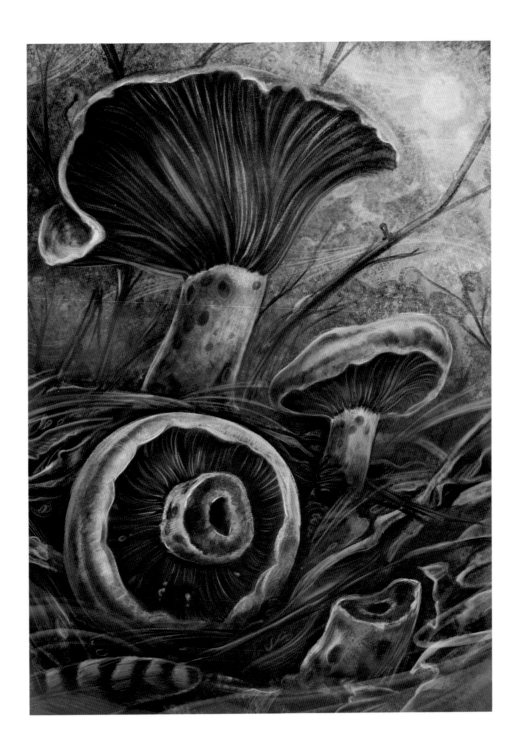

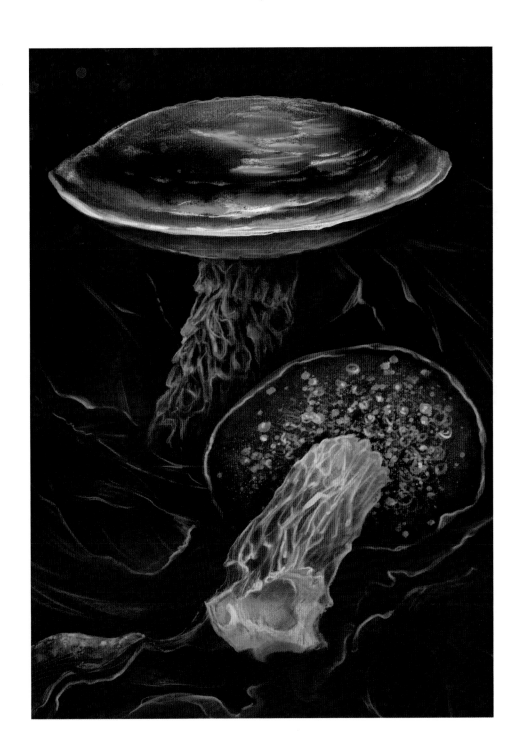

5" × 7"

8" × 10"

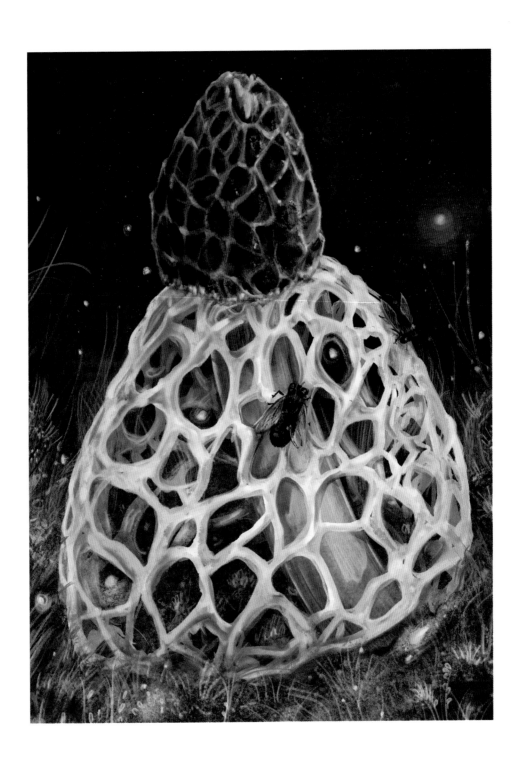

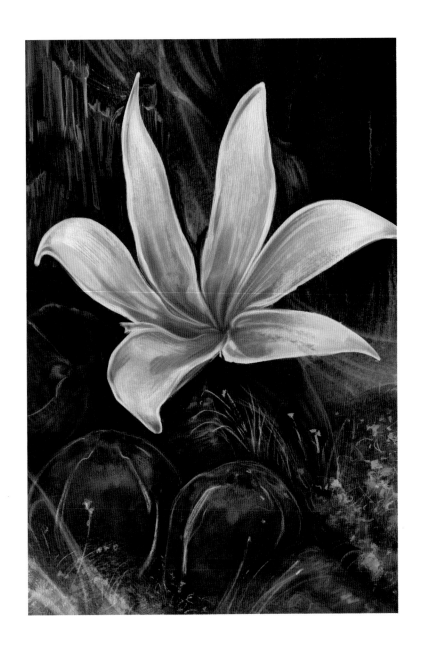

4" × 6"

5" × 7"

8" × 10"

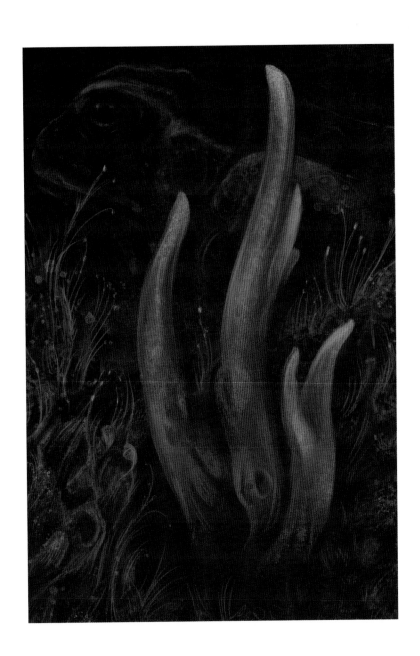

4" × 6"

5" × 7"

8" × 10"

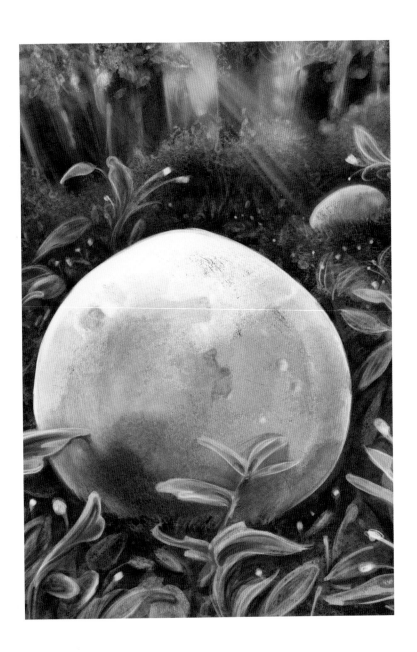

4" × 6"

5" × 7"

8" × 10"

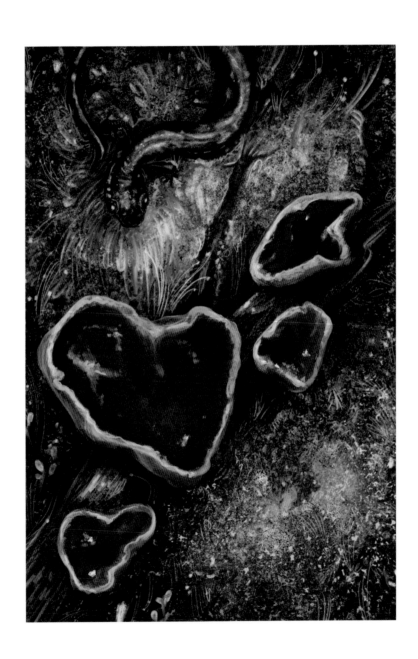

4" × 6"

5" × 7"

8" × 10"

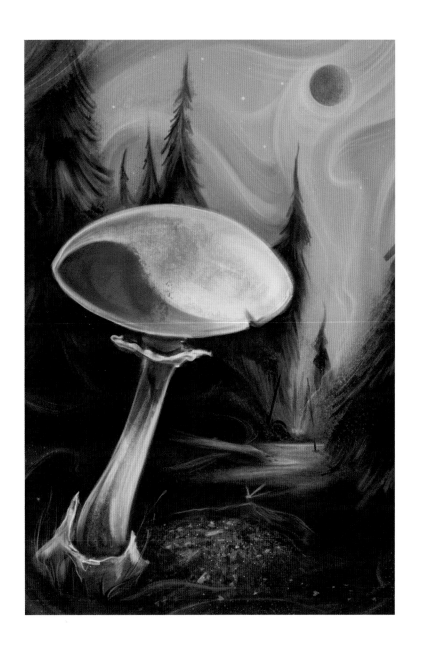

4" × 6"

5" × 7"

8" × 10"

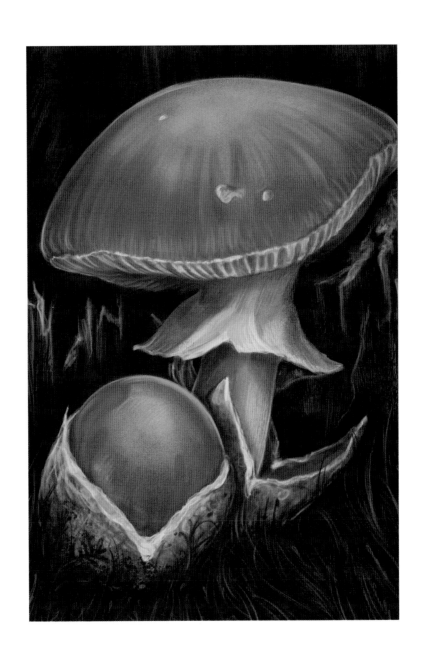

4" × 6"

5" × 7"

8" × 10"

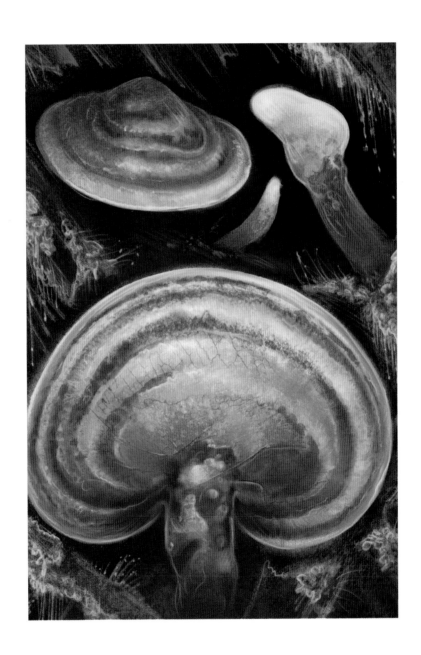

4" × 6"

5" × 7"

8" × 10"

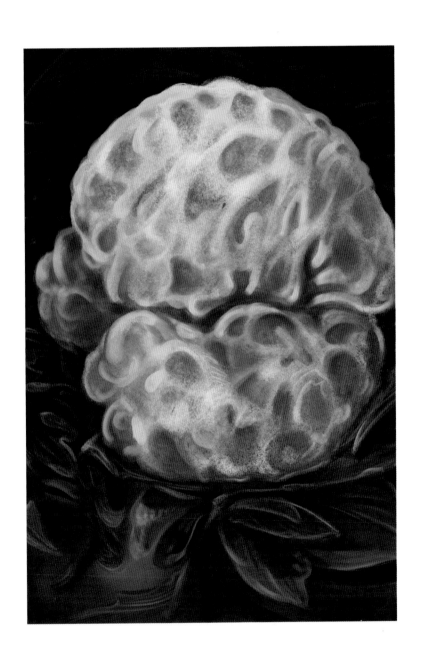

4" × 6"

5" × 7"

8" × 10"

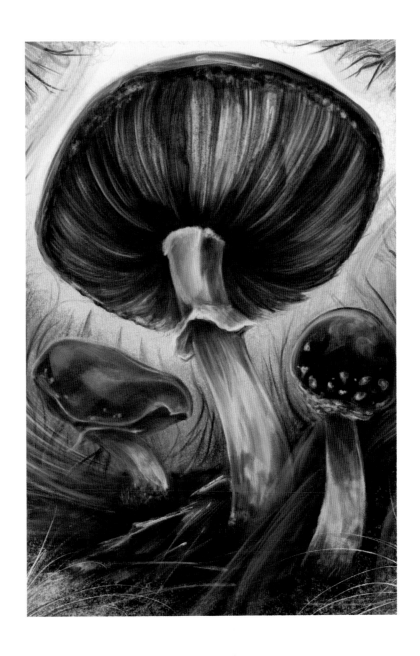

4" × 6"

5" × 7"

8" × 10"

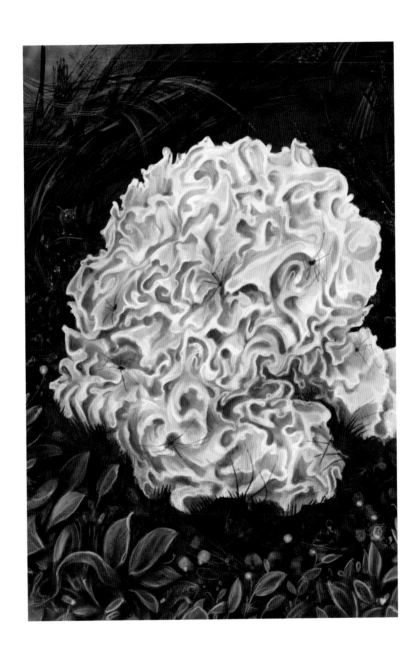

4" × 6"

5" × 7"

8" × 10"

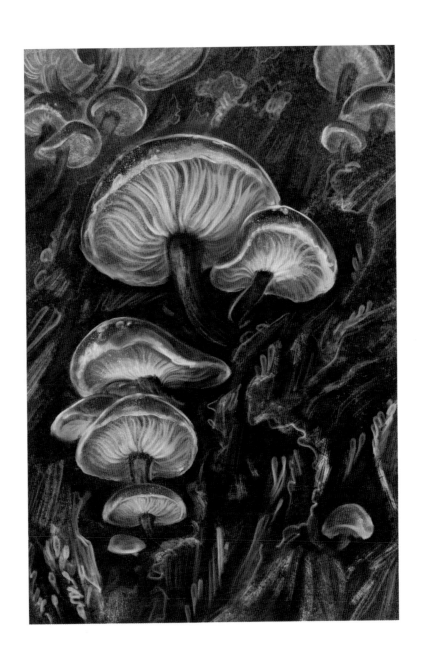

4" × 6"

5" × 7"

8" × 10"

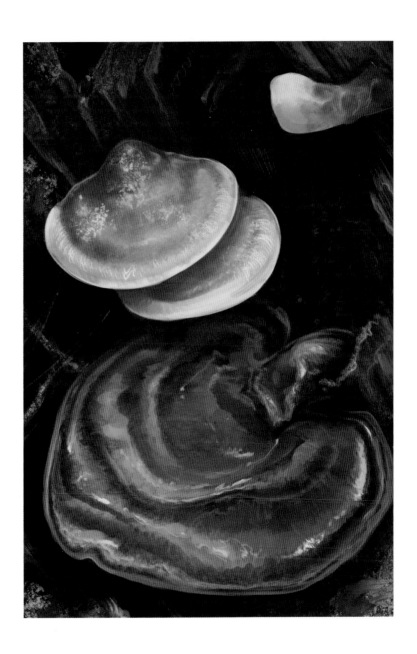

4" × 6"

5" × 7"

8" × 10"

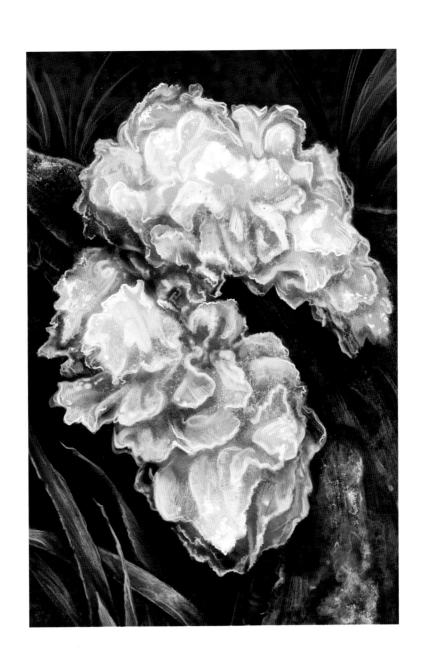

4" × 6"

5" × 7"

8" × 10"

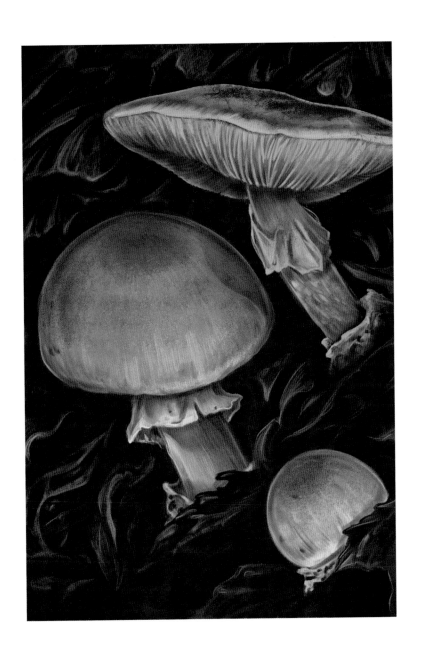

4" × 6"

5" × 7"

8" × 10"

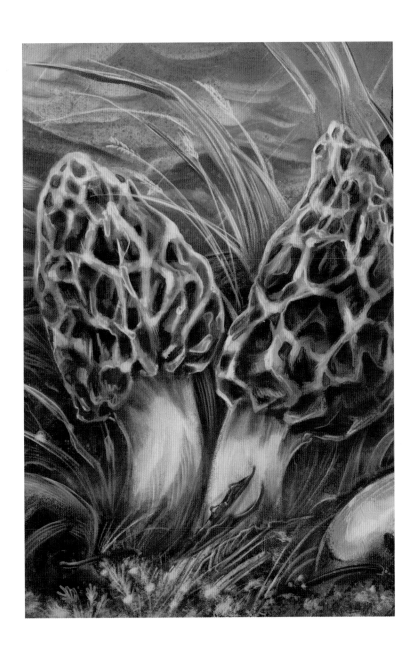

4" × 6"

5" × 7"

8" × 10"